P9-DVH-821

Paper Collage

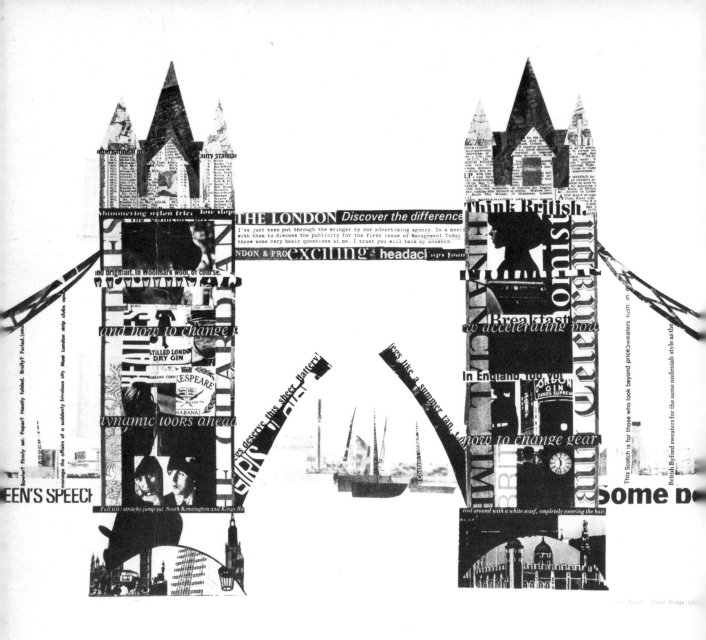

Paper Collage

Robin Capon

Charles T. Branford Co. Newton, Mass. 02159

Filmset by Keyspools Limited, Golborne, Lancs
Printed in Great Britain by
Pitman Press, Bath, Somerset
for the publishers
Charles T. Branford Co.
28 Union St.
Newton, Mass. 02159

Contents

Acknowledgment

My thanks are due to Alitalia Italian Airlines for allowing me to include Sauro Bertelli's *London Collage*. This was designed for the 1967 Alitalia calendar and is reproduced on page 2.

Foreword

The term 'collage' can be loosely defined as picture-making
by attaching objects or shapes to a support. This practice was
introduced by the Cubists early this century, and has since
been greatly developed and extended. It is a form of picture-
making that can be adapted to all age groups and levels of
ability.

This book is confined to paper collage. Many of the different
forms of paper collage are examined, starting with simple
divisions of paper and leading on to combinations of media
and techniques. As with other art forms, collage has its own
particular limitations to which the artist must discipline
himself. Work can so easily become stylized, involving only
an arbitrary selection of textures, colours and shapes. It is
important to experiment and to be imaginative, yet at the
same time always self-critical. The choice of shapes and
colours, as well as their interrelationship within the design,
needs much thought. Nevertheless collage techniques can
help to dispel inhibitions and provide a freedom and almost
immediate form of self-expression. The collagist is able to
select from a wide range of materials and techniques. In the

case of paper collage the process is basically one of selection and then pasting the chosen shapes to a support. Whilst other art techniques may require specific knowledge and demand the following of set rules and procedures, assuming the availability of materials, paper collage work can often be successfully completed at a single session or within the normal length art lesson. In the tearing, handling and pasting of materials there is direct physical contact. This, coupled with the simple basic techniques makes most collage methods fairly spontaneous forms of expression. Work with cut, torn, and folded paper has a useful part to play in artistic development and education.

Some may find it is better to cut or tear directly into the paper, rather than work to a definite, preconceived idea. Obviously, it is necessary to have ideas in one's mind, perhaps even sketches on paper, but accurate reconstruction of a carefully planned design can defeat the object of collage as a form of expression. Inspiration might come from a number of sources, from nature, textures or the work of other collagists, for example. Likewise designs in collage can be extended to other craftwork, such as fabric design.

Among modern artists, examples of collage can be found in the early work of Braque and Picasso as well as in the work of Dadaists and Surrealists. Max Ernst, Kurt Schwitters and Henri Matisse have produced exciting and inspiring work involving collage.

In many schools collage is included in the art teaching; the direct approach and handling of materials make this a useful technique when dealing with backward or abnormal children. Because we use paper to draw and paint on, we often neglect it as a means of expression, yet it offers exciting possibilities for picture-making. Papers of different textures and colours can be explored and many different techniques

can be used with 'ready-made' shapes cut from magazines or photographs. The aim of this book is to stimulate an awareness of the possibilities that collage offers. The illustrations and text combine to describe a particular technique or idea, but the illustrations should not be considered as the ultimate expression of that idea. It is hoped that the reader will use the material in this book as a starting point for his own work and will not merely copy. Many of the ideas are open to numerous variations and developments, far too many to illustrate within the confines of a single book.

The equipment is extremely simple and available in most homes, schools or studios. It is surprising what a wide variety of pictorial effects can be obtained by using glue, papers and a pair of scissors.

1 Dividing

The student who is unfamiliar with cut paper techniques should begin with some simple exercises. Initial work should aim to develop an awareness of shape and design, to engender confidence with the medium, and to give experience of the basic technicalities of cutting and gluing. These are points which are especially important when using more advanced collage techniques described later in this book. The selection of a particular shape, its relationship to the design as a whole, accuracy of cutting and neatness of pasting are vital to good collage.

A useful starting point is the examination of the various ways in which a simple shape may be subdivided. By cutting into a shape new shapes will be formed, and by spacing out slightly a new relationship and balance will be established, since the spaces *between* shapes are just as important to the completed design. With preliminary work it is advisable to cut in one direction only and not to combine straight cuts with curved. It is also important, to begin with, to retain the original shape; a rectangle may be subdivided, for example, but retains its overall rectangular shape, as in figure 3. Later

work can combine different cuts as well as involve the transformation of the basic shape. First exercises should use pieces of paper at least 200 mm (8 in.) in length.

Basic shapes could be circles, squares, rectangles or triangles. The shape selected is carefully drawn, cut out, and cut up into its various parts. These are then arranged on

1 Basic rectangle

2 Division by a single vertical cut

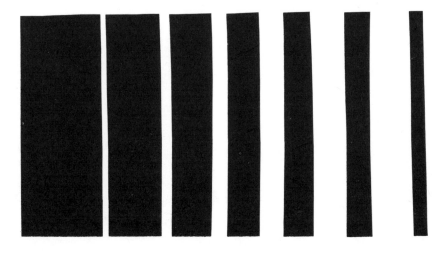

3 Subdivision by vertical cuts

4 Subdivision by vertical cuts

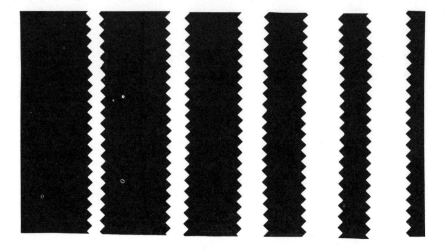

5 Subdivision of a rectangle

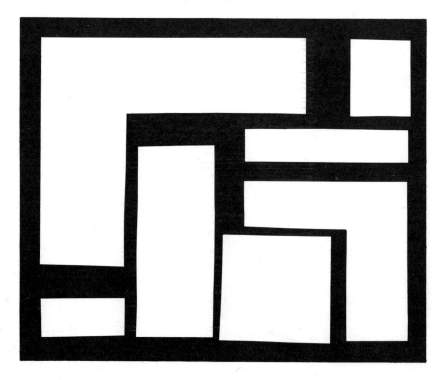

backing paper of a different colour. Nothing is added or taken away. When a satisfactory arrangement of the various parts has been made, the pieces are pasted down.

A combination of black art paper and white cartridge (drawing) paper makes exciting contrasts, but this does not exclude the use of other colours, providing there is good definition between shapes and background. As with all sub-sequent work in this book involving the use of scissors, it should be noted that good quality, *sharp* scissors are best for most work, though small children, obviously, will manage better with smaller pairs. For ordinary quality paper, a thin, free-flowing glue is required. Notes on materials and pasting are to be found at the end of this book.

Various ways of splitting up a rectangle are illustrated in figures 1 to 7. Examples 1 to 4 show vertical cuts into the basic

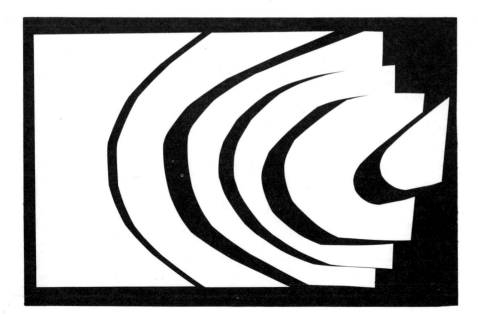

6 Splitting-up with curved cuts

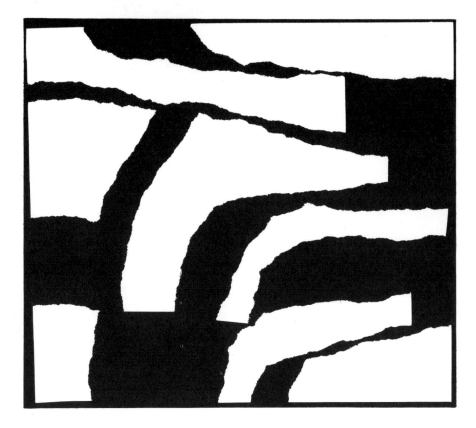

rectangle. Often more effective results are obtained if limitations are imposed on the method of subdivision. It is noticeable from these few examples how the character of a shape can be radically changed in this way.

Figure 4 illustrates the use of pinking shears to give serrated edges to the constituent shapes. In figure 6 a curved cut is used, whilst in figure 7 the pieces have been torn.

The division of paintings, photographs, magazine cut-outs and so on in this way can give surprisingly effective results. Such work is exciting because of the shattered image effect

created by a contrast between the parts of the design and the gaps which surround them (see figures 8 and 9). With a regular subdivision, as in figure 9, it is essential to make accurate measurements and cuts.

Much of this type of cut paper and collage work can be related and linked to other art and craft work, and also to other types of school work. Designs formed by shape subdivision or expansion, for example, bear obvious links with basic design work for crafts such as fabric printing and marquetry. With the lower age groups, the division of shapes

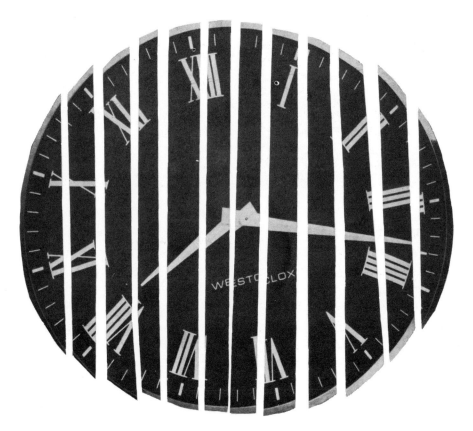

8 Vertical division

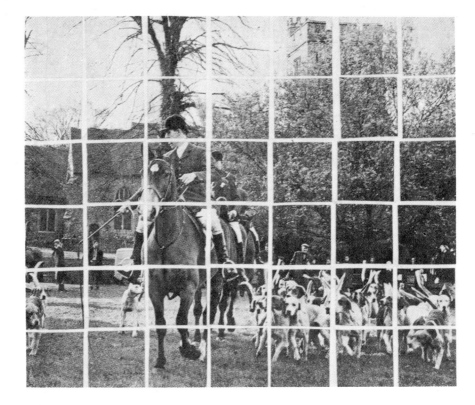

could relate to number work. Working with cut paper could therefore combine both mental and creative faculties.

2 Extended designs

Shape division can be used to form designs in which the basic character of the original shape is changed by expansion. Again, a single piece of paper is cut into a number of smaller pieces, though in this instance the direction and type of cuts may be varied. In the remade design the pieces are spaced out so that there is an interplay between positive and negative areas, perhaps resulting in the loss of the original basic shape. Individual shapes are kept in their appropriate positions, merely being spaced out from those surrounding them. If the parts could be pushed together they would form the original shape; nothing is added or taken away.

Illustrations 10 to 17 were all made by direct cutting into a basic shape with scissors. Preliminary drawing should not be necessary; one is, in effect, drawing with the scissors. In certain cases, when dividing into strips for example, it is advisable to use a sharp knife against a straight-edge. Paper of a suitable size, type and colour should be selected. As the parts are cut out, they should be placed in their appropriate position on the backing paper. It is better not to glue anything down until final decisions have been made as to the overall design.

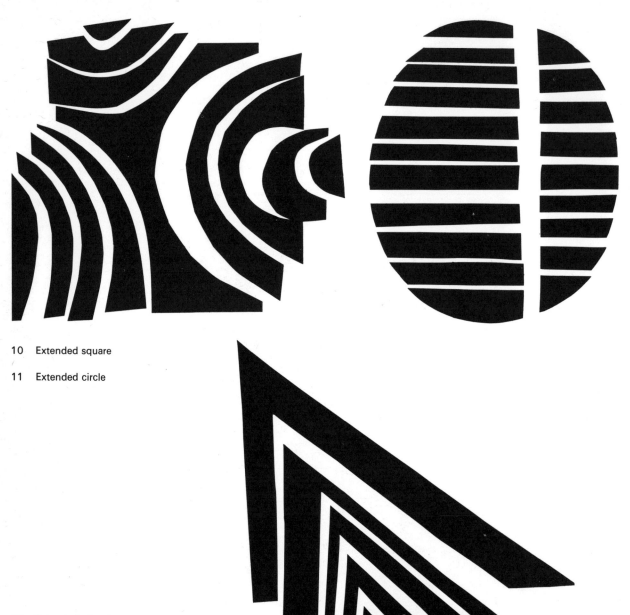

10 Extended square

11 Extended circle

12 Extended triangle

18

With extended designs spacing is vitally important. The examples suggest many further possibilities as well as a link with basic design, illustrations, posters and other art techniques.

Figure 10: extended square; three basic cuts with further subdivision.

Figure 11: extended circle; one basic cut, each part then subdivided.

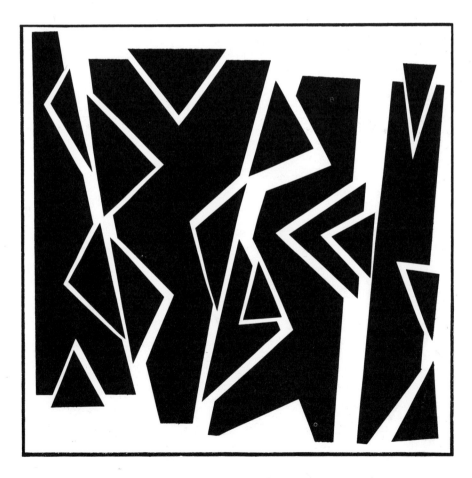

13 Dividing and extending

Figure 12: extending a triangle by cutting out successive triangles.

In figure 13 the basic shapes have been further subdivided and extended.

Cutting and spacing out can produce bold and impressive designs, as with the faces in figures 15 and 16 and the design by a fifteen-year-old boy in figure 17. In figure 15 the variety

15 *(opposite)*
Extended design

20

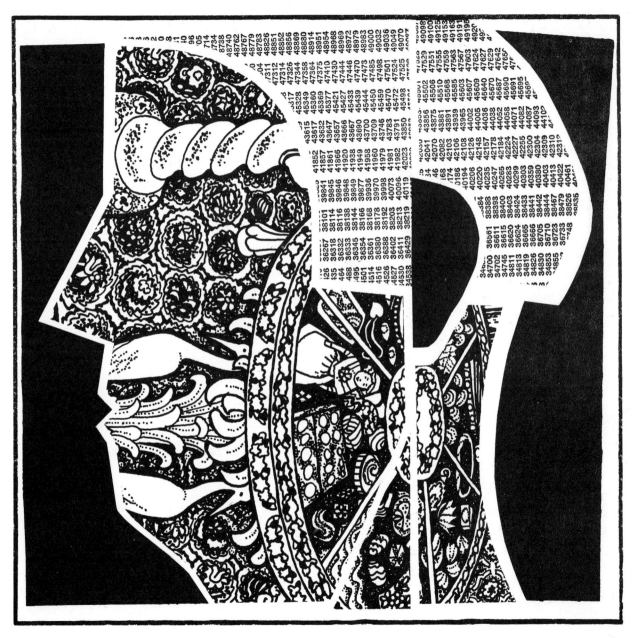

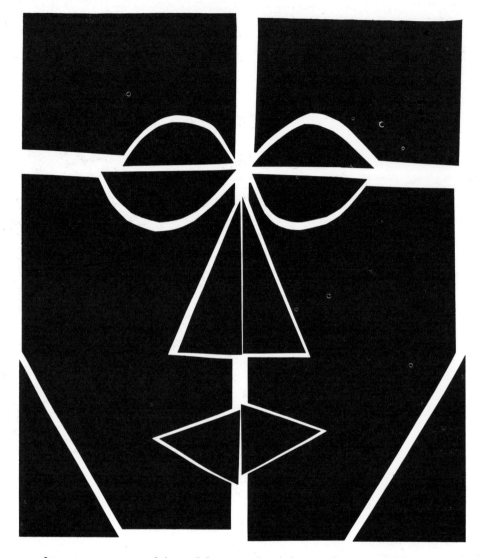

of texture was achieved by cutting through several layers of paper at once, then rebuilding the design by using some parts of each layer. Work involving this technique is dealt with in more detail in section 13 of this book.

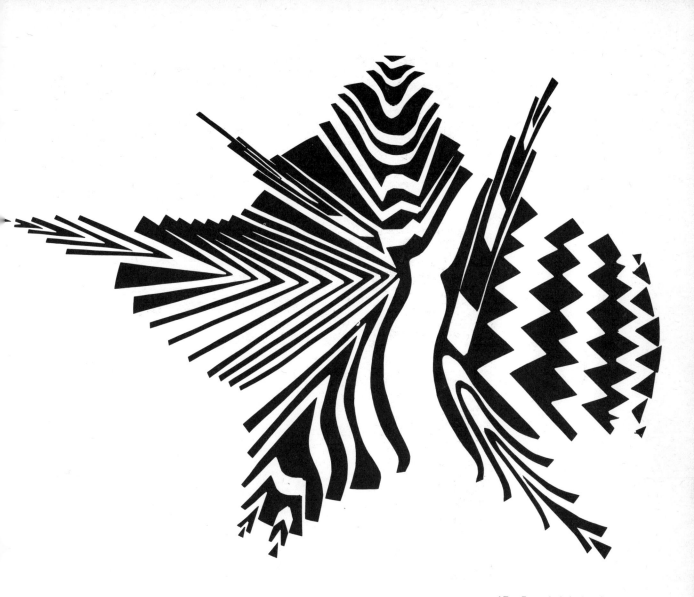

17 Extended design from a
circle by a boy aged fifteen

3 Cutting and rebuilding

A shape can be further transformed by division and rebuilding. In this case, the separate parts need not be reassembled in the same order as in the original shape, though, as explained later, certain forms of subdivision impose limitations in the rebuilding of the shape. In the examples illustrated the constituent parts have generally been reassembled in a different order to create a new image or shape. Spacing has not been used, though it is obvious that with certain forms of division it could be employed.

Certain methods of division allow no choice in the way the parts are reassembled. Where there is a choice, as with vertical strips, for example, it is important that each part is not only selected in relation to bordering parts but also to the design as a whole. It may be necessary to experiment with various pieces, trying them in different positions, before a final solution is reached. It is therefore important not to paste down anything before the complete design has been worked out. Once again, it is usually necessary to use all parts of the subdivided shape.

Precise work is essential with this technique. The different pieces very often have to be identical so that they may be interchanged. Straight cuts are best made by using a sharp

knife against a straight-edge. Curved cuts can be started with a razor-blade or knife, then completed with scissors. Sharp, pointed scissors will be most suitable for the more intricate cuts. It is essential to work in a well-organized manner; it may be possible to build the new design while shapes are cut out, otherwise the various parts should be kept in order so that they may later be alternated or interchanged.

The technique of division and rebuilding may be applied to a variety of graphic art forms. Photographs, magazine cutouts, paintings, drawings, rubbings, prints and even other collage work may be cut and reassembled in this way.

Various ways of dividing and rebuilding are illustrated in figures 18 to 25.

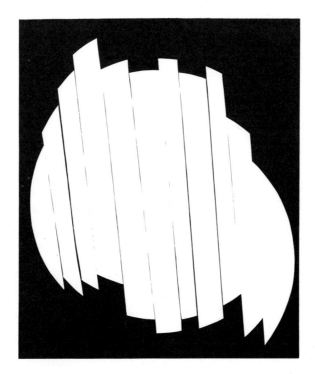

18 Rebuilding a circle

Figures 18 to 20 show division into strips. Figure 18 shows how a basic shape, a circle, can be altered simply by slightly moving individual parts. Although the strips are used in their correct sequence an entirely new shape has been formed. This practice can be applied to any silhouette, and division could be by vertical, horizontal, or diagonal cuts.

In figure 19 two photographs from a magazine were used. The photographs were identical in size and their image similar in shape and size. Each photograph was cut into the same number of strips of equal width. The strips were used

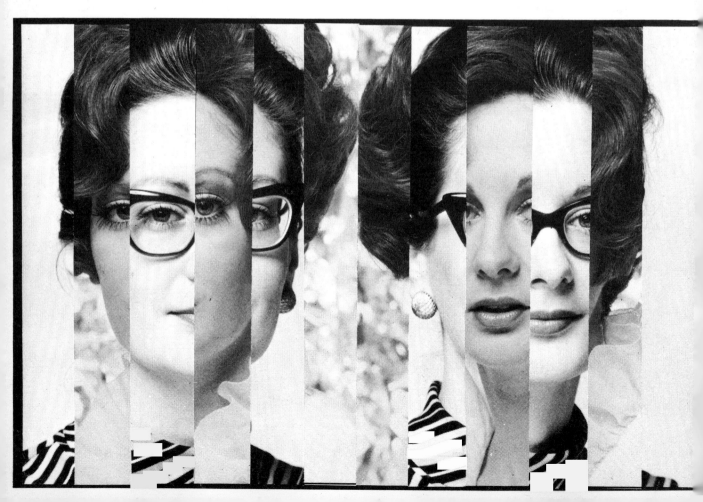

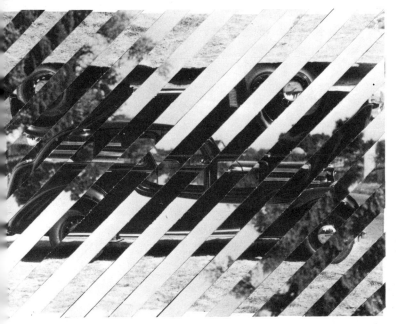

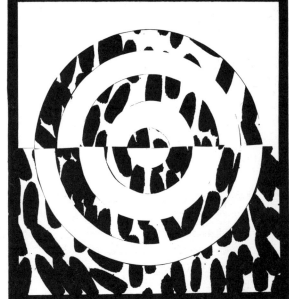

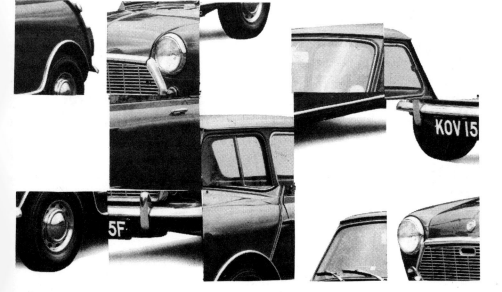

20 Diagonal strips used alternately

21 Semicircles with alternate reversing

22 Rearranged squares

27

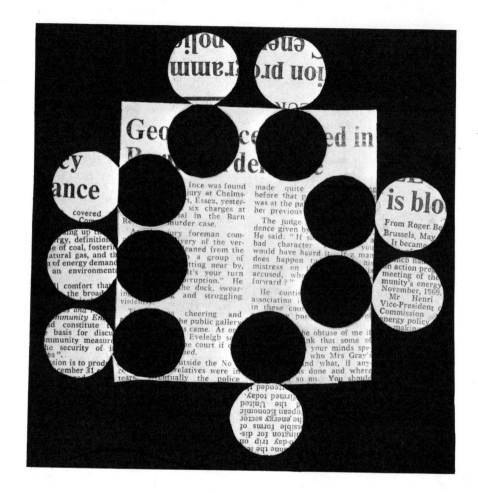

alternately to make the completed design.

A division into diagonal strips is illustrated in figure 20. It is important here to use strips of equal width and to be precise with measurements and cutting. The original photograph was rebuilt using alternate strips from top left and bottom right. The poorest photograph or painting can be enlivened in this way.

Alternate shapes have been reversed in figure 21.

Apart from division into strips, circles, squares and other geometric forms, a template can be used to draw round. This will give identical shapes which can then be cut out and interchanged. See figures 23 and 41.

Shapes can be cut out after folding the original photograph or design. Again, cut out parts can be replaced in a different sequence or reversed, as in figure 25.

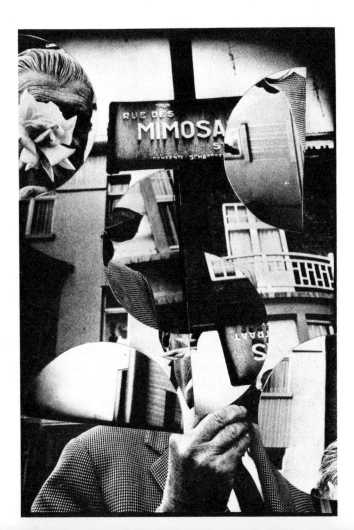

24 Rearranged semicircles

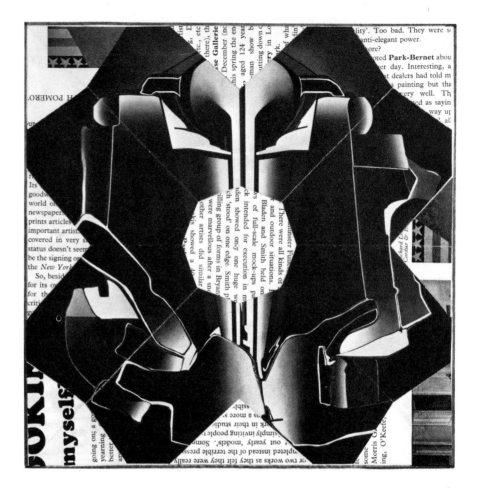

Collage pictures produced by these methods can be very effective. There is room for endless variety and experiment.

4 Cutting and folding back

This is another technique which involves the extension or transformation of a basic shape. Again, no parts are added or taken away. In this case cut out parts are folded back from the position they originally occupied so that they form an extension opposite it. There is thus a strong interplay of positive and negative shapes in these designs.

The idea befits an abstract interpretation (figures 26 to 28), and experiments can be made with photographs and various types of textured papers. It is advisable to start with black and white paper, using simple forms. Later more variety can be introduced, perhaps using paper with a different colour on each side.

Many different possibilities are suggested by figures 26 and 27. The cut out parts in figure 28 have been folded back internally so that they overlap on to the basic shape. Paper with a different colour on each side must be used in this instance; this can easily be made by pasting two sheets of different coloured paper together before use. In figure 28 graph paper was pasted to black art paper.

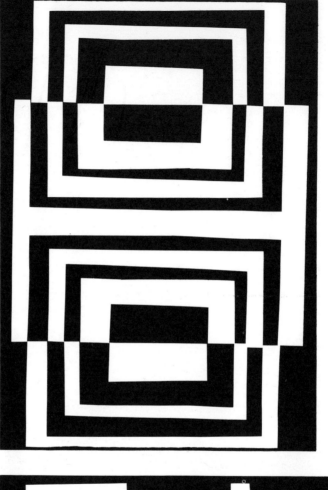

26 Cutting and folding back:
a square

27 Cutting and folding back

32

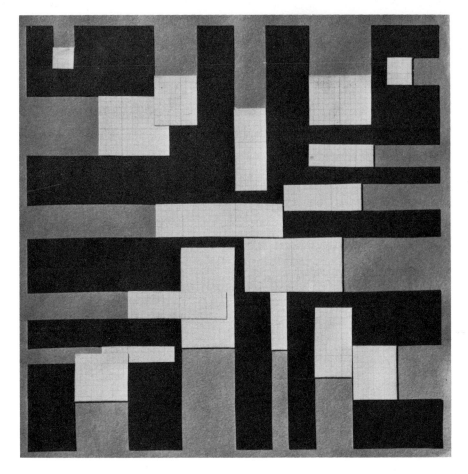

5 Folding

Designs can be made from shapes or strips of paper which have been folded in various ways so as to give different degrees of tone. This technique could be combined with cut and torn shapes to build up a collage picture.

All types of transparent and semi-transparent papers can be used. Tissue paper is ideal, particularly when the lighter colours are used against a dark supporting background.

Working with folded paper can begin with simple designs using a basic shape, as in figure 29. Here, a square of white tissue paper has been folded across itself in various ways before being pasted on to black backing paper. Again, the result is to create an entirely different shape. The new shape incorporates areas of different tone, the depth of tone depending on the number of times the paper has been folded. The same principle might be applied to other simple shapes cut from transparent paper; designs might consist of a number of these shapes, using different colours.

Thin, clear paper glue is required for this work; it should be used very sparingly as it is apt to leave marks, especially with tissue paper. Glue need only be applied to the corners of individual shapes.

Figures 30 and 31 illustrate the use of folded strips of paper.

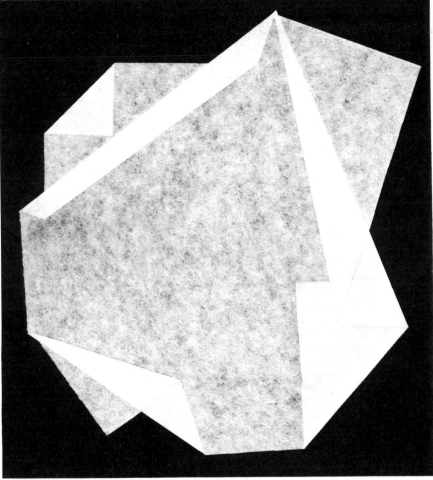

In figure 30, pieces have been overlapped. Various colours and widths can be used and strips can be torn as well as cut.

In designs such as figure 31, one is virtually drawing with strips of paper. The technique here is to fold the strip whenever necessary to cause a change in direction.

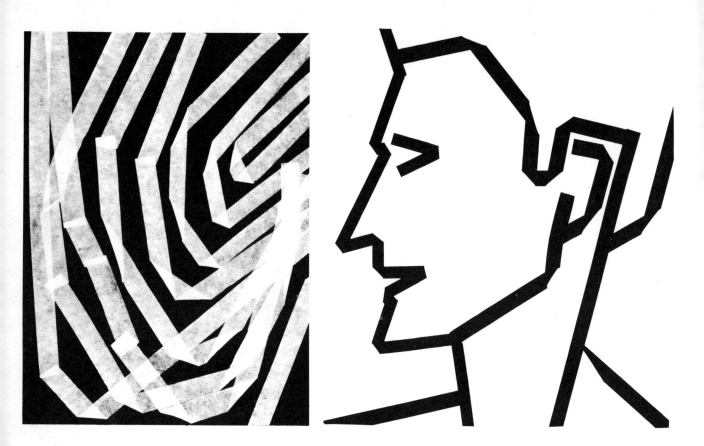

30 Folded strips

31 Designing with folded strips

Working with strips of paper is further illustrated in section 12.

Shapes may also be cut out in duplicate from folded paper. A sheet of paper folded over several times could have various shapes cut out along the folds. When opened out this may either be used as a decorative roundel or silhouette, or have pieces cut or torn from it for use in collage compositions.

6 Froissage

The surface of paper can be altered by creasing, ribbing, and wrinkling, suggesting movement and rhythm. In a representational picture this is a technique which could be used to suggest a particular surface, such as water. Creased and folded areas can be made to contrast with flat pieces of paper.

Paper may be wetted or used dry for this technique. Tissue papers and Japanese papers are the most responsive, though others, such as sweet papers, fruit wrappings, and newspaper may be used successfully, as in figure 32.

The paper may be crumpled up beforehand and shapes then torn or cut and glued in place. Heavy papers must have glue applied to their underside, whilst tissue papers can be held in place and then brushed over with liquid glue. Alternatively, the paper may be laid on to a prepared, glued surface, being creased *in situ*.

Froissage can be used together with veiling, déchirage and other techniques. Dubuffet, Burri, and Crippa are among artists who have used this method in their collage work.

32 Using crinkled and folded
paper shapes

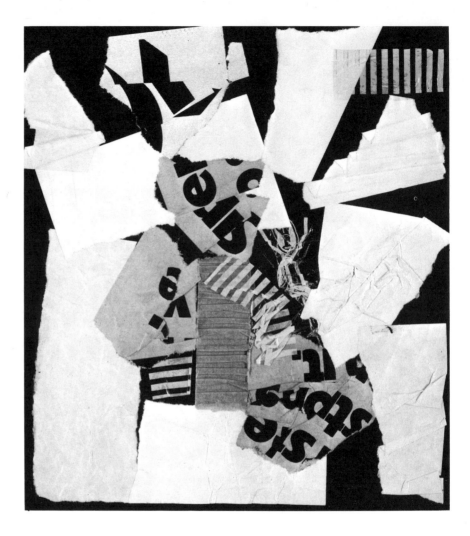

7 Silhouettes

Silhouettes can be effective in themselves or may be used in collage work, as in figure 47. They also provide scope for composite pictures or freize work in which a variety of cut out shapes, perhaps painted, are glued on to a suitably painted or collaged background.

Silhouettes should normally be confined to a small scale; large-scale work tends to become over simple and less interesting. They are most effective if black on white or white on black. The work is easy to execute and can produce exciting results. The involvement with the design and cutting out of a basic shape as well as the need to consider positive and negative shapes, solid areas of design against blank areas of the background, makes the cutting of silhouettes useful introductory work to more complicated techniques with cut paper and collage.

To make a silhouette areas are cut from a basic shape. There are several methods of approach: shapes may be cut from the edges (figure 36); from the interior; by cutting on a fold (figure 34); or by cutting from both edges and interior (figure 37). The two main points to remember are first, to make the shape interesting, and second, to keep the cutting and gluing as neat as possible.

Shadows made to fall across a sheet of paper can form interesting shapes which can be drawn round, cut out, and used as silhouettes.

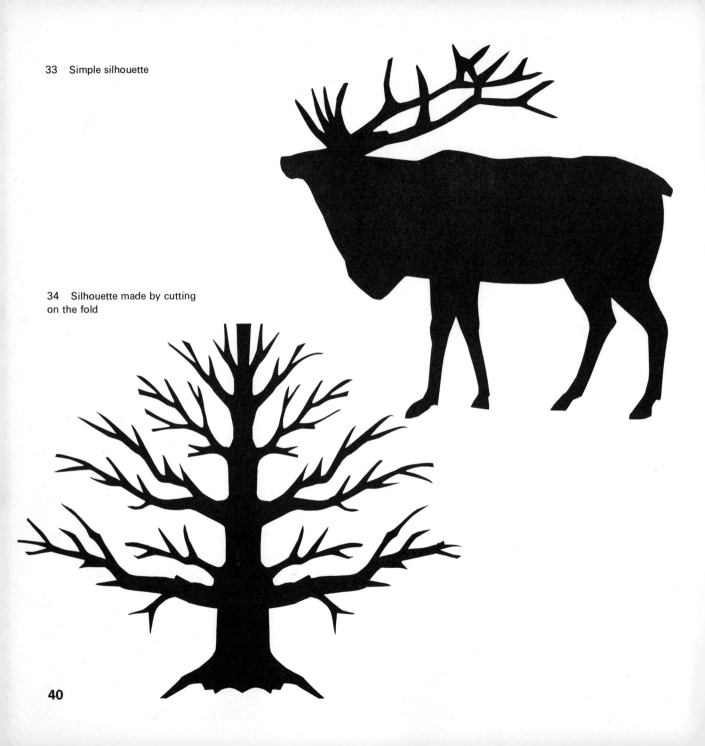

33 Simple silhouette

34 Silhouette made by cutting
on the fold

40

35 Silhouette with added brushwork

36 Silhouette

37 Silhouette with inner cuts

8 Découpage: collage with cut shapes

The techniques described so far have examined how basic paper shapes can be cut up and the new shapes thus formed used to make a design. Each method is open to countless variations and each is useful as preparatory work for the more advanced collage techniques which are now explained. The earlier methods will normally produce simple, effective results, from a single original shape. On the other hand, a variety of shapes can be cut from many different paper surfaces to form a collage. Picture-making in this way will make use of specific textures or colours to convey an idea.

Découpage entails the use of clean-cut lines in building the design. As with all collage, it should be emphasized that the juxtaposition of shapes and textures should be carefully thought out.

The cutting tool, whether it be scissors, razor-blade or knife, must be sharp, so that crisp, clean cuts are made. Papers of different weight, quality and texture may be used. Paper or card may be stained or painted before cutting. This can be done by pulling the paper through a tray of water-colour or by painting it over with a large brush. Sheets

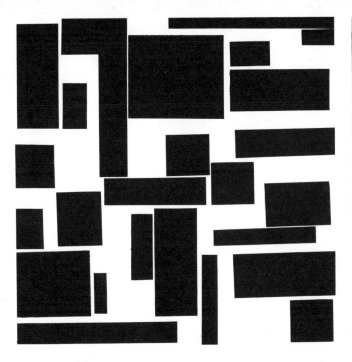

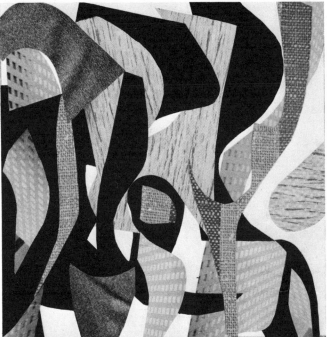

38 Designing with cut-out
shapes

39 Overlapped shapes

40 *(above)* Using a variety
of surfaces and tones

coloured in this way should be pegged up to dry before use. Interesting printed papers can be cut from magazines and newspapers, whilst embossed and textured papers are obtainable from various packaging materials and wallpaper.

Normally all the shapes are arranged on the backing paper so that alterations can be made to the final design before any parts are glued down. Shapes can be overlapped and transparent papers can be superimposed so as to create variations in colour or tone. Drawing and brushwork can be used on the completed collage.

Basic design work in cut paper may take the form illustrated in figures 38 and 39. In figure 38 shapes cut from black art paper have been arranged on a white background. Careful thought has been given to the white areas; these play an equally important part in the total design. The effect of such

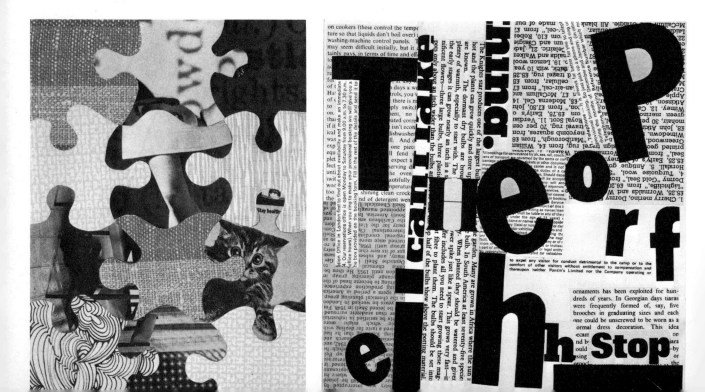

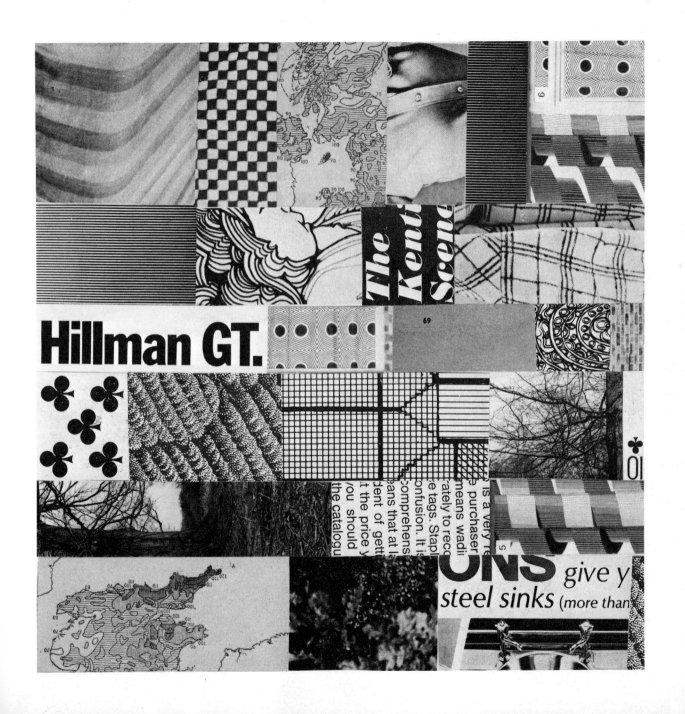

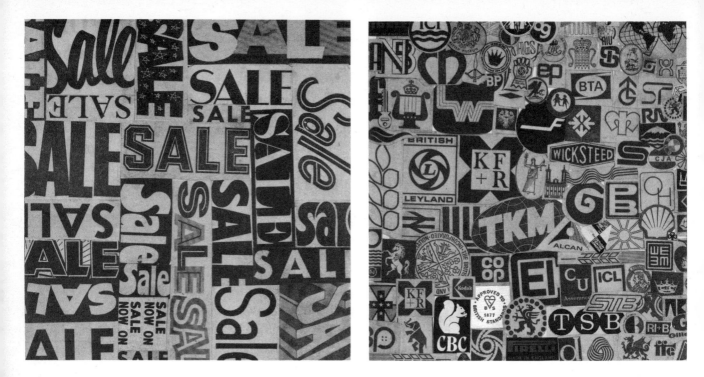

44 Image repetition

45 Collage from cut-out trade-marks

designs frequently depends on a limitation of the types of shapes used; shapes might be similar but of different sizes, or identical shapes could be used in different positions. In figure 39 circles cut from newspaper and black art paper have been overlapped and used to form a repeat design. These two ideas suggest other avenues of exploration leading to numerous variations.

With imaginative cutting and well-thought-out interrelationships the results will be far more interesting. Scissors can be just as expressive as a brush or pencil. Henri Matisse, who during the last ten years of his life produced many *papier collé* compositions, said 'Scissors can achieve more sensitivity than the pencil.' The effect of the crisp edges formed by the scissors together with the use of tonal relationships is illustrated in figure 40.

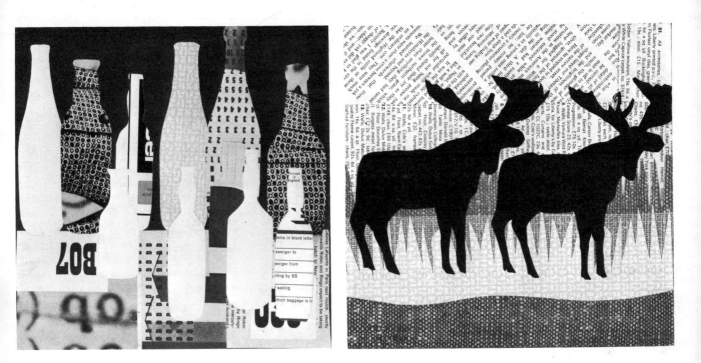

Identical shapes can be made by drawing round a template and cutting through several sheets of paper at once. In figure 41 the shapes were made by using parts of a jigsaw puzzle as templates.

Print provides a wide variety of surfaces and its use is demonstrated in figure 42. Similarly, figure 43 makes use of many different types of paper, including photographs, print, and pictures cut from magazines. The shapes here were cut to fit into exact rows; they do not overlap.

Representational pictures should use shapes which have been cut from specific colours and textures to relate to the object or idea which they are trying to convey. A wrinkled paper could be used to create an impression of water, for example, whilst overlapped semi-transparent papers give the idea of clouds.

46 Cut paper design

47 Cut paper collage

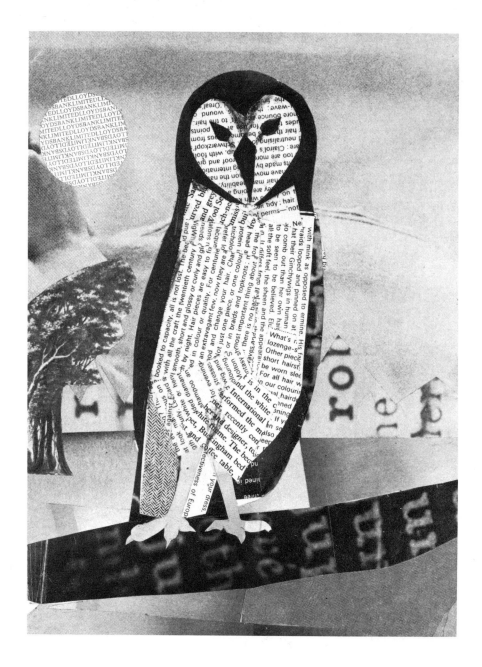

9 Paper mosaic

This technique will require a reserve of various colours and textures from which pieces can be taken as required. Areas of colour can be cut from magazines, colour supplements, brochures, catalogues, etc., and these used in conjunction with other coloured papers and gummed papers. It is also possible to use printed areas cut from newspapers, magazines or old photographs for tonal work. It will be discovered that printed areas, particularly black, vary in intensity, even within the page of a single magazine. Such tones are useful for mosaic work, this being illustrated in figure 49.

Paper mosaic collage might result from work on the history of mosaic or visits to local examples. This is an ideal technique for group projects. Although simple mosaics with gummed paper can be made by quite young children, this is a technique best confined to older students, as the cutting and gluing will involve a certain amount of intricate work demanding time, patience and skill.

Small pieces of paper of about 12 mm ($\frac{1}{2}$ in.) square are used to build up the design, which, of course, will be stylized. Inspiration for this work could come from examples of

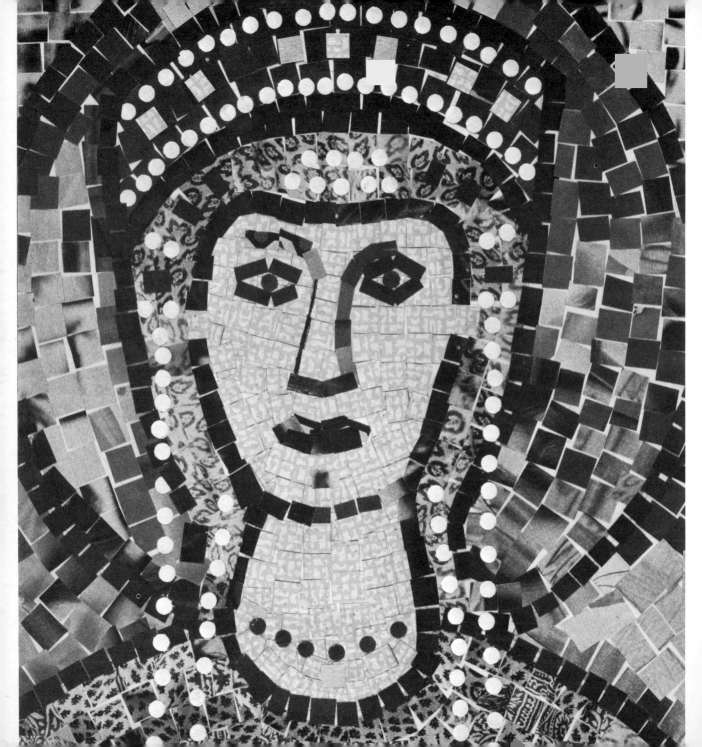

Roman or Byzantine mosaics, as illustrated in figure 49, which combines the use of mosaic with punched paper circles. The best method of working is to start with the main design and then to work outwards from this, filling in the background. It is quicker to cut off strips of paper about 12 mm ($\frac{1}{2}$ in.) wide and then to cut these into approximate square shapes. The small squares of paper may need to overlap in some instances in order to achieve a particular shape. In a simple large area it is necessary to employ a subtle variation in colour from square to square. In this instance the backing paper should be glued and the small pieces pressed in place on it. As with similar types of collage, finished work can be varnished, if required, with a thin paper varnish or thinned PVA Medium.

49 *(opposite)* Paper mosaic

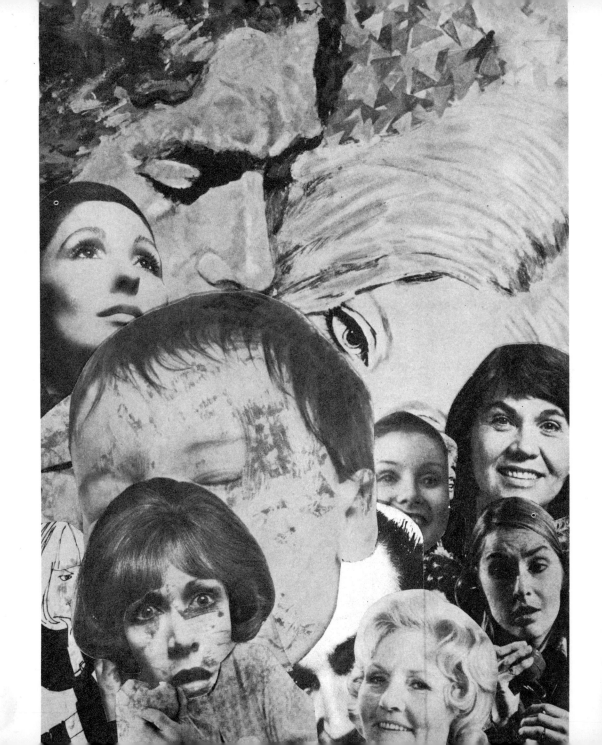

10 Photomontage

In the context of paper collage, this technique may be defined as the pasting of cut-out parts of photographs from various sources into a montage. These cut-outs should appear to merge with their new background as well as with each other, so that it is not evident that they are, in fact, separate, glued-on parts of the design. The technique has its parallel in trick photography involving the combination of negatives, over-printing and other techniques. Fantasy and optical illusion play an important part in the design. Edges and tones can be blended so that one cannot differentiate between the individual shapes. Photomontage was widely practised by Dadaist and Surrealist artists.

Subject matter may be based on a particular theme, as in figures 50 and 51, or the work may rely for its effect on a variety of totally unrelated objects, perhaps unified by a common setting, Other work might explore unusual juxta-positions of objects or shapes, fantasy, or absurdity.

Apart from the skill required in relating tones and shapes, such work will rely to a large extent on accuracy in cutting out and care in pasting and positioning. Suitable material will be found in magazines and newspapers as well as old photographs, posters, etc. It may be easier to work in mono-chrome, as tones are usually easier to match.

50 *(opposite)* Photomontage

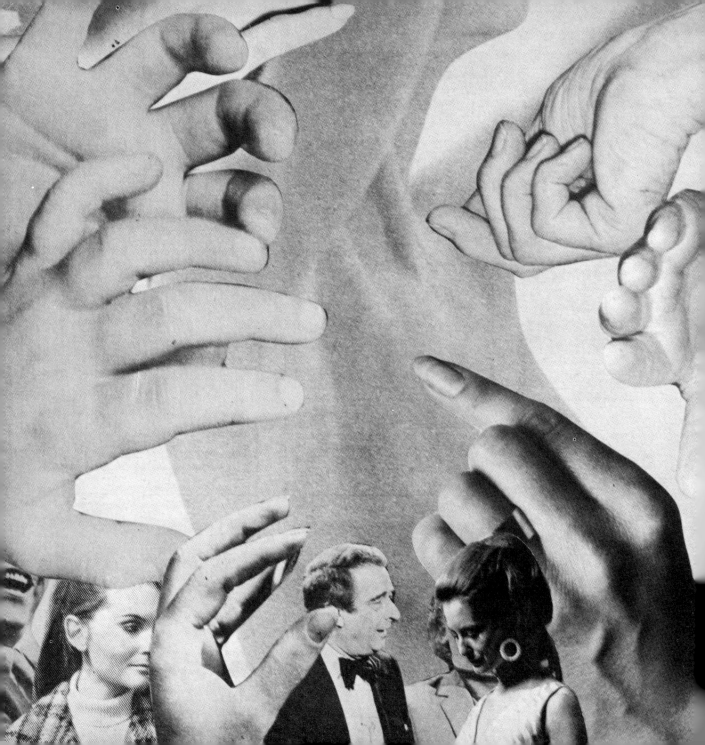

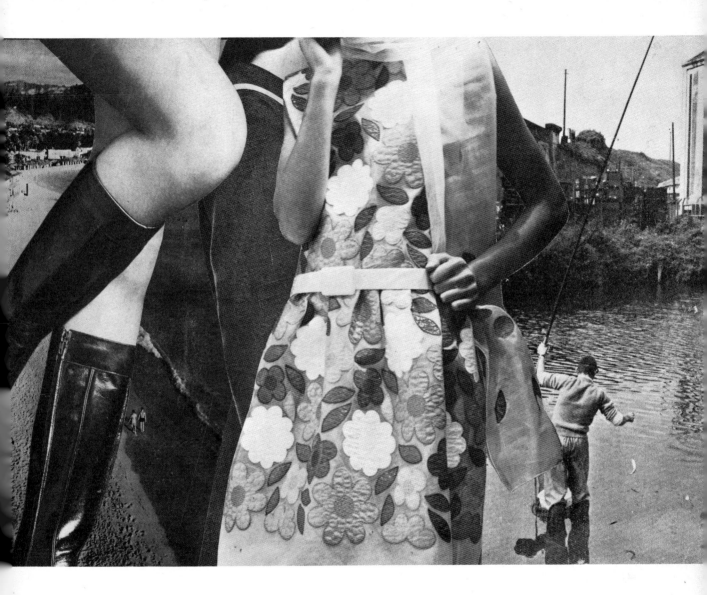

51 *(opposite)* Photomontage

52 Photomontage

11 Paper assemblage

As the name implies, this technique is concerned with the collecting and assembling of material on a support in collage form. This may involve any material but is usually taken to mean work in three-dimensional form. This can lead to exciting, perhaps large-scale, work in relief. With the variety of materials available, such work can easily result in a confused jumble of shapes or objects which has no 'message' or meaning. The process of 'assembling' must therefore attempt to associate different objects, shapes or colours into a coherent whole. Kurt Schwitters and Max Ernst are two of the well-known artists who have used this technique.

Because of its wide-ranging possibilities it is essential to plan the work carefully. Paper assemblages might range from shallow relief work, using cut shapes from paper or cardboard, to the use of paper or cardboard cartons. It is therefore necessary to consider the materials required, the type and strength of glue needed, and the support. The use of paper and card is considered here, though one should not overlook other materials such as wood, hardboard, empty cans, nails and screws, corks, plaster, and scraps of plastic, *Formica*, celluloid, and *Perspex (Plexiglas)*. These could be combined with paper and cardboard.

In general, assemblage work will be done on a fairly strong base or support. For relief work in paper and cardboard, a thick cardboard support will suffice, but heavier, three-dimensional work must be constructed on a solid base such as backed hardboard or plywood. A craft knife used against a metal straight-edge can be used to cut out the card and paper shapes for building up layers of relief. Cartons, tubing and

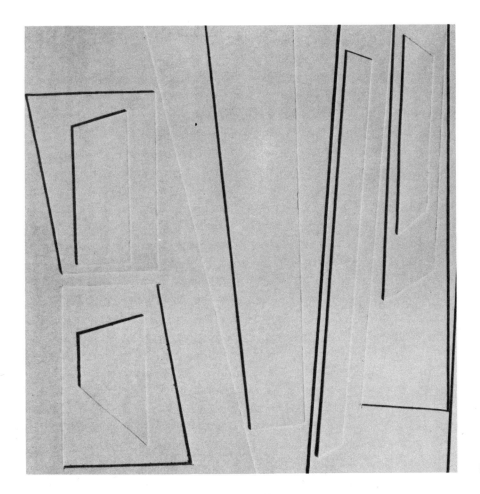

53 Card relief

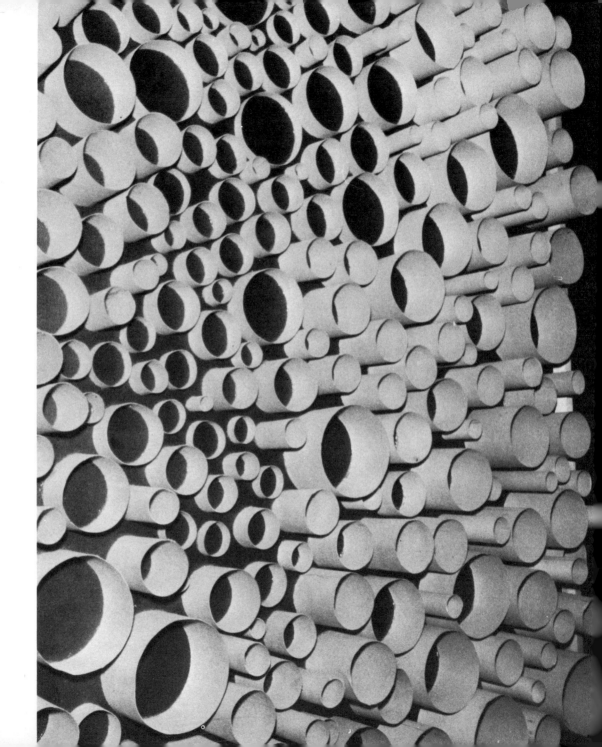

heavy cardboard will require the use of a stronger glue such as *Copydex*, *Uhu* or *Bostik*. Alternatively, the surface of the support might be coated with plaster or thick paint such as PVA or acrylic paint, into which various objects or shapes are impressed and allowed to set. Assemblage pictures can be sprayed or painted in some other way, and varnished if required. Work carried out on a large scale can be mounted on hardboard.

Relief work with card shapes is illustrated in figure 53; these shapes are glued to a cardboard base. The example makes use of subtle differences of shadow caused by light falling on a surface which varies in relief but not in colour (white). Shallow relief collage using corrugated and heavily embossed papers is further illustrated in figure 55.

In figure 54 paper cylinders of various sizes have been glued to a painted hardboard base. The cylinders in this instance were made by coiling lengths of paper around cylindrical objects such as pencils and dowelling. The ends of the lengths of paper were slightly overlapped and glued together. Cardboard tubing can be cut to various lengths and used in the same way. Other objects such as empty yoghourt cartons, paper cups, egg cartons, small cardboard boxes, foil paper, etc., can be glued to a suitable support or impressed into a prepared surface to make an assemblage.

54 *(opposite)* Design with paper cylinders

55 *(overleaf)* Using embossed and heavily textured papers

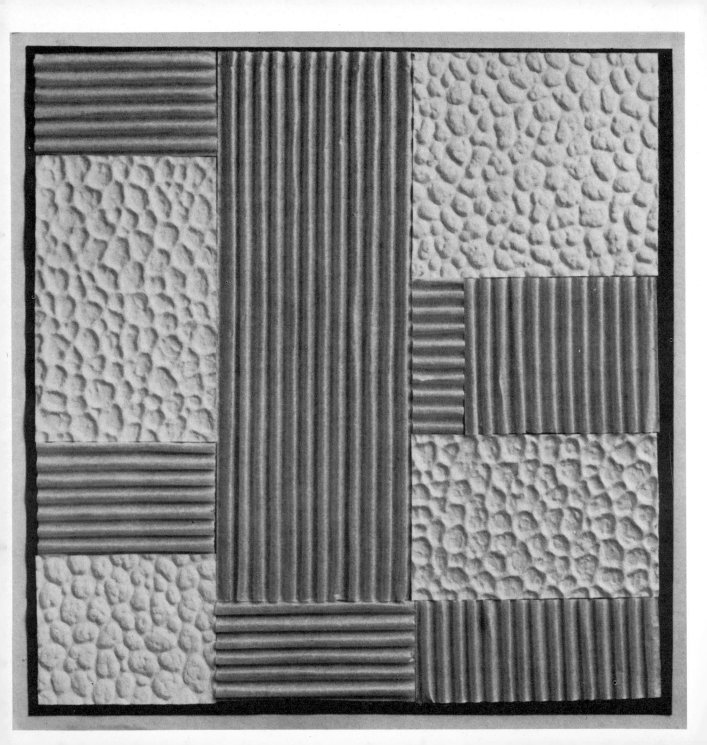

12 Using strips of paper

Collage pictures may be built up by using strips of paper cut from various sources. The strips may vary in width and length. One can in fact 'draw' with lengths of paper by the skilful use of different lengths, by folding, and by over-lapping. Other techniques involving strips of paper have been mentioned and the reader is referred to figures 8, 11, 18, 19, 20, 30 and 31. This is a technique which can be adapted to all levels of ability and which can produce results of sur-prising sophistication.

Figure 56 illustrates a simple exercise in basic design using strips of different lengths cut from black art paper. As with similar designs previously illustrated, the relationship be-tween positive and negative shapes must be considered. It is usually best to arrange all the strips on the backing paper so that alterations to the design can be made before gluing.

In figure 57 strips cut from a variety of papers have been arranged so as to form interesting contrasts between various tones and textures.

Simple picture-making using strips of paper is illustrated in figure 58.

56　Designing with strips of
paper

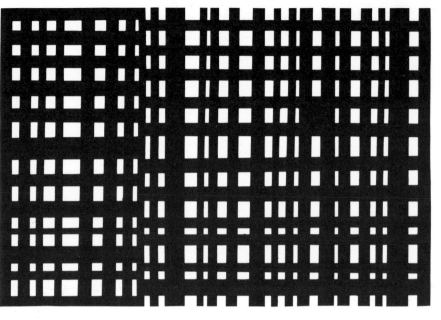

57　Strips cut from various
papers

58　Picture-making with
strips of paper

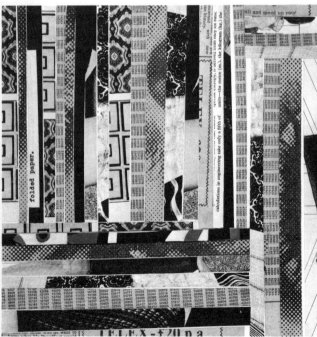

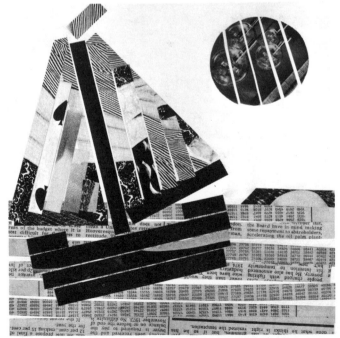

13 Cutting through several layers

If various parts of pictures are cut out, cutting through several layers of different coloured paper at the same time, the pictures may be rebuilt using shapes of each colour. The thickness of the paper will determine how many sheets are cut through at once; with tissue paper it is possible to use six or more layers together.

The sheets of paper are selected to give contrasts in colour or texture. It is preferable to use sheets of identical size; these may be held together with paper clips whilst the shapes are cut out. The design can be drawn in on the top sheet of paper or shapes can be cut directly from the layers of paper. It is essential that the various layers fit together exactly so that when they are cut identical shapes are made. With complex designs, to save time and confusion, it is advisable to cut out the shapes in a particular order, so that each set of shapes is in a separate pile but is kept next to those which bordered it in the design. In this way selection of individual pieces is easier and rebuilding the design is quicker since one is not starting from a jumbled mass of pieces. In rebuilding the design one should use pieces from each type or colour of paper. These are glued to a suitable backing paper.

It will be obvious, as in figures 60 to 62, that if three sheets

59 Cutting through several layers

of paper are used, then three separate designs can be made. On the other hand, as in figure 59, the shapes can be used in a composite way to form one large picture.

Again, this is a technique which can be adapted to all age groups and which can be linked with pattern work; shapes cut from folded paper or from several layers of paper being used to build up a pattern, involving the repetition of a shape and perhaps using a variety of colours and textures. Where a large number of identical shapes have to be cut for this purpose a template can be used. A template can be an object, a plastic shape, a piece of a jigsaw or can be made by cutting a shape from a piece of card. This is used to draw round on the top sheet of paper so that identical shapes can then be cut out. See also figure 15.

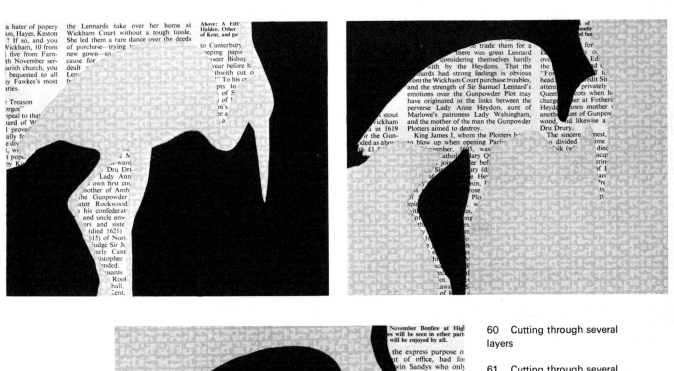

60 Cutting through several layers

61 Cutting through several layers

62 Cutting through several layers

65

14 Veiling

Interesting effects can be achieved by pasting layers of paper on top of each other. Tissue paper, celluloid, crêpe paper and transparent papers of all types, including sweet wrappings, etc., are particularly suitable for this technique, lending themselves to numerous possibilities. It is possible also to use pieces from these types of paper so as to cover or partly cover shapes cut from textured and other non-transparent papers. Such designs can incorporate both cut and torn pieces.

Deliberate restriction in this technique is advisable. Designs which involve a multiplicity of shapes and colours may well be less effective than those confined to a smaller range. It is recommended therefore that to begin with work is limited to two colours. These may be combined in various ways, creating additional tones or colours in overlapped areas. The background colour is also important; this should be chosen to suit the particular colours of paper being used. Intricate work with this technique is not possible, and the theme of the collage should be a fairly simple one.

A clear paper glue, such as *Gloy*, is best for this sort of work. Glue should be applied sparingly because it is apt to leave marks on these types of paper; it need only be applied

to corners. Tissue and other transparent papers tend to wrinkle when glued; one can usually counteract this successfully by allowing the work to dry out under pressure, as described in the *Technical Notes*.

In figure 63 Japanese paper has been layered to form various tones as well as to veil other cut-out shapes.

Veiling is a useful technique to combine with other types of collage, for example déchirage, and may be used to investigate tonal or colour relationships. It is allied to work with folded paper as discussed in section 5 and froissage, section 6.

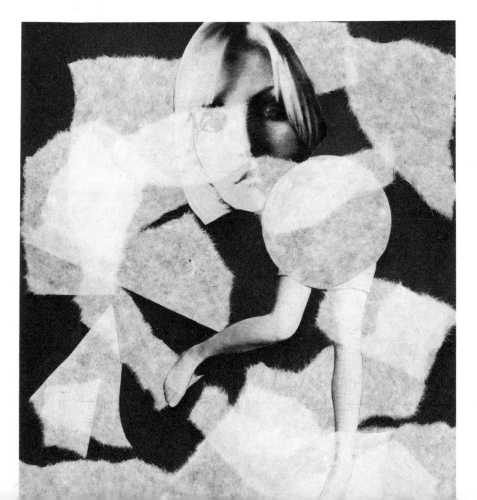

63 Veiling

15 Positive/negative designs

This is another technique where sheets of paper are cut through together. In principle, the positive/negative technique is identical to that explained in section 13, *Cutting through several layers*, except that here only two sheets of paper are used. The best results are generally achieved by the combined use of black and grey, or black and white. Cartridge paper is the most suitable.

Both sheets of paper are cut through at once, so that two of each shape are produced. When all the pieces have been cut out the design is rebuilt using alternate black and white (grey) shapes.

Two variations are illustrated. In figure 64 all the parts have been used to form a composite design. In figures 65 and 66 the pieces have been used to make separate designs, figure 66 being the opposite or negative of figure 65.

Such work can be executed on a large scale. In this case the paper design can be mounted on hardboard.

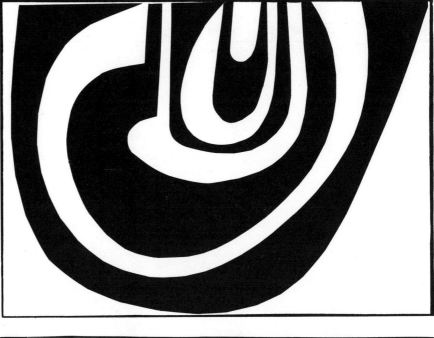

65 Positive design

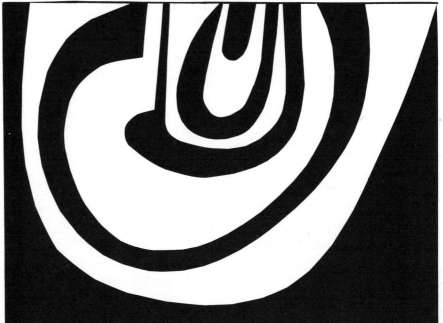

66 Negative design

70

16 Déchirage

Déchirage, the use of torn paper, embraces many possibilities. Tearing is a more spontaneous and individual method of expression, the frayed edge contrasting greatly with the rigid delineation made by the knife or scissors. The directness of approach and the physical contact with materials, leads to a form of self expression comparable to that of the sculptor and potter. The torn edge is particularly suited to overlapping, layering and veiling techniques.

Inspiration for this kind of work might come from everyday sources as well as from some of the notable collagists working this technique. Striking examples of déchirage may be seen in torn hoardings (billboards). Here, the combination of accidental and deliberate tearing away of various layers of posters often produces results of surprising effectiveness. Among collagists, Robert Motherwell is a leading exponent of *papier déchirage*.

Once again, a disciplined approach to the work is necessary in order to achieve worthwhile results. The torn edge cannot be controlled accurately and it is primarily this accidental quality which characterizes this technique. It is left to the collagist to accept, adapt or reject individual torn shapes. Papers will tear differently; some producing a crisp edge,

whilst with others, such as Japanese paper, a frayed edge is formed, a quality which can be exploited in the collage. Paper can be torn against a straight-edge, though the freer, more expressive method of approach is more typical of this work.

The scale of working can vary. As with all paper collage it is possible to work on a large scale, using hardboard or plywood as a support. Most types of card and paper are suitable, Japanese rice papers and tissue papers especially. Liquid paper glue is best for this work. The glue can be applied to the pieces of paper or they can be worked into glue which has been brushed on to the support. Children often find this technique an enjoyable and spontaneous method of creating which can also be combined with other methods of using paper or with other media.

A simple torn paper collage using pieces torn from black

67 Torn shapes

68 Tearing and veiling

art paper is illustrated in figure 67. With abstract work it is possible to start designing without any preconceived idea, tearing out a number of shapes and then arranging them in the design area. Arranging and rearranging continues until a satisfactory solution is reached and the shapes are glued down. Alternatively one can build from a shape or shapes already glued down.

Figure 68 combines various tones and textures with veiled shapes. Déchirage is ideal for pictorial work, as illustrated in figures 69 and 70, and can be challenging to the imagination and ingenuity.

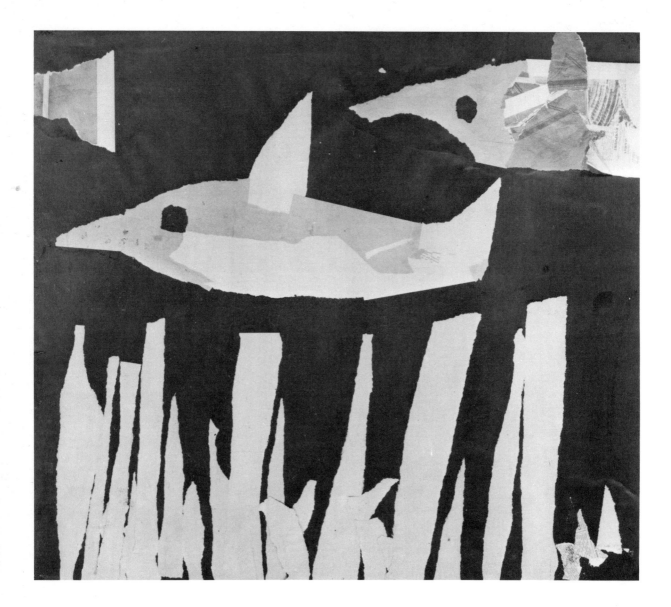

70 Torn paper collage by a
thirteen-year-old boy

74

17 Décollage

The process of ungluing or tearing away the paper from a collaged surface is known as décollage. With such collages the basic procedure is to stain several sheets of paper with water-colour, acrylic, oil paint or ink, then to glue these together layer upon layer. Parts are then wetted and peeled away, producing areas of contrasting colour or tone. The normal method is to tear pieces away, though definite shapes can be carefully scored out with a razor-blade or sharp knife and removed.

Papers can be toned or prepared in various ways before layering. Surface rubbings (frottage) techniques can be used and these can be combined with textured, sprayed or printed papers. Coloured papers could be used to produce a gradual progression of tones. It can be easier to use sheets of paper of identical size, though this is not essential. The selected papers are pasted one over the other so as either to overlap or completely cover the layer beneath. A support of thin card is often the most suitable for this technique.

There are various methods of working: shapes can be torn away while still moist with glue, as illustrated in figure 71, though there may be difficulties with this technique in working a 'controlled' design; the surface can be wetted with water before peeling away; lines can be scored with a knife and shapes unpeeled from the cut edge; and brûlage techniques can be used to disturb the surface before tearing away (section 20).

Completed décollage work might have cut out, painted, fumage, or other work added to it. The final design may require an application of varnish or fixative.

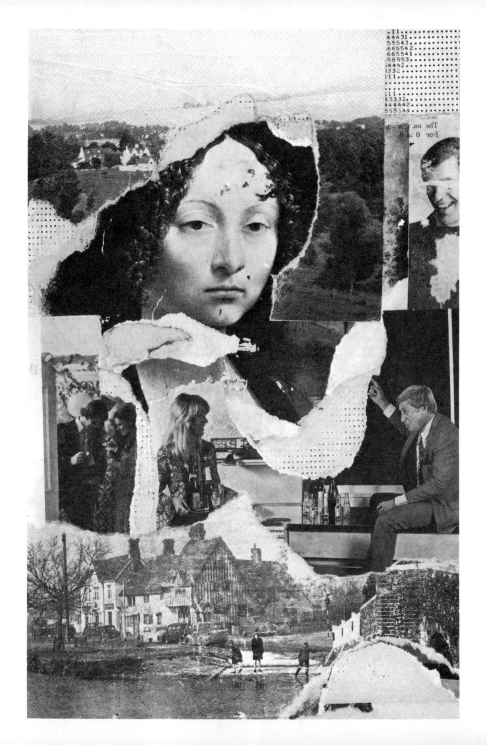

18 Collage combining cut and torn shapes

Often a number of different techniques are used in one collage. The combined use of cutting and tearing could involve most of the methods illustrated in this book. Collage pictures can exploit the partly accidental quality inherent in the torn edge, contrasting this with the precise delineation of shapes cut out with a knife or scissors. Information on techniques involving cut and torn paper has been detailed in sections 8 and 16 and thus will not be repeated here.

Consideration must be paid to the relationship between cut and torn edges. Designs might be composed of shapes which are associated in some particular way, for example torn and cut sections of faces, as illustrated in figure 72.

72 *(overleaf)* Using cut and torn shapes

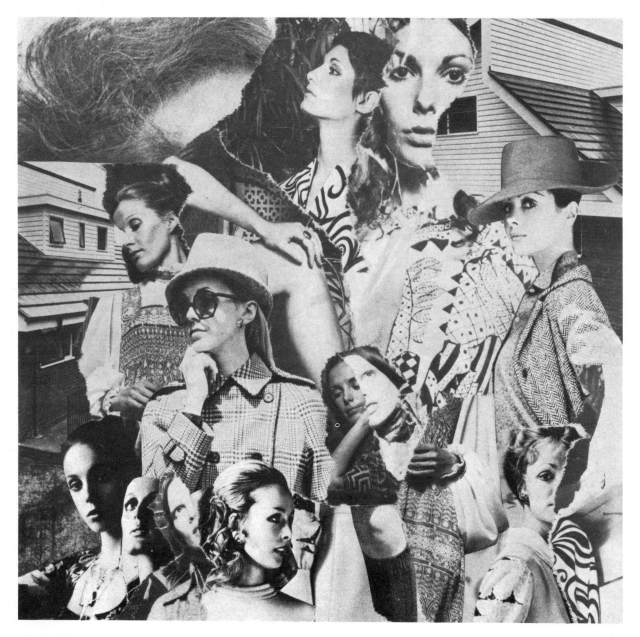

78

19 Collage from found materials

Creative work must rely to an extent on the materials available. The enthusiastic collagist will be constantly looking for interesting papers with which to work. Art papers can be supplemented with a variety of other waste and discarded material. Labels, tickets, check-out slips, stamps, playing cards, corrugated paper, foil paper, photographs, negatives, scraps of wallpaper and sandpaper, as well as pieces cut or torn from newspapers, magazines or old books can all be used. The collecting of materials might be governed by specific ideas for collage pictures or the materials themselves might suggest or inspire a particular piece of work.

The collagist may be ingenious and imaginative but at the same time he must use thought and discrimination if the work is to have real value. This applies particularly to the use of waste papers which may bear little obvious relationship one to another.

Most waste papers may be cut and torn and used for many of the techniques already described. With heavier quality

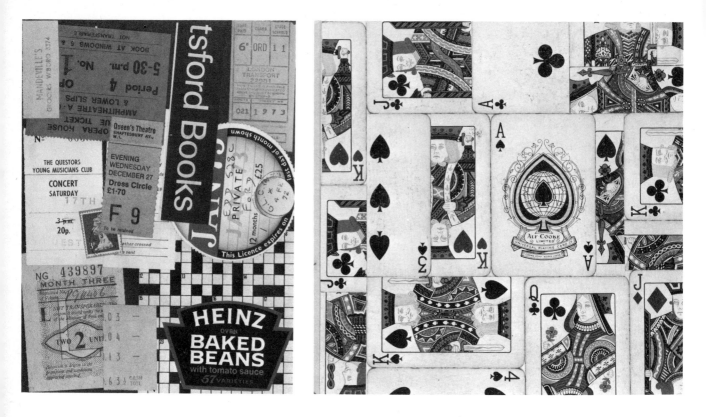

73 Collage from 'found' papers

74 Collage from playing cards

materials and papers (foil tops, tickets, corrugated card-board, etc.) it is advisable to use a stronger glue such as *Copydex*, *Bostik* or *Uhu*.

An arrangement of one particular type of found material often produces an interesting collage. This is illustrated in figure 74 which was built from one whole playing card and sections of others. A collage from waste materials is also shown in figure 73.

20 Brûlage and fumage

Brûlage is the burning of paper by passing it over a candle flame. The paper may be used wet or dry, although more controlled work is possible if the paper is damp. The charred edges of paper will produce interesting shapes and subtle tonal gradations.

There are three methods of working: the paper may be burned before being used in the collage; a layered collage may have parts burned away in a similar fashion to décollage; or the burned shapes may be allowed to fall on to a prepared ground of wet plaster, glue, or acrylic paint. Alberto Burri is among collagists who have used this technique.

When dry, the completed collage should be fixed with a clear vinyl medium (*Marvin Medium*, *PVA Medium*, *Cryla Matt Medium*, etc.), fixative, or varnish.

Fumage is closely allied to this burning technique, but in this case the paper is merely toned by the smoke and not actually burned. This is done by passing the paper over a flame fairly quickly so that the smoke stains the surface. This carbon deposit can be smudged with the finger if required and, as with brûlage, the finished work will need fixing.

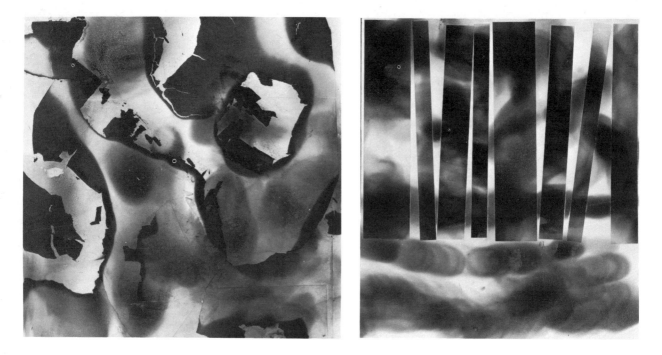

75 Brûlage

76 Fumage

In figure 75 the collage was made from burned and partially burned shapes of paper. The completed collage was afterwards passed over a candle flame, using the fumage technique to create further tones.

A similar method was used to create figure 76. Here the strips of paper were cut from a sheet on which the fumage technique had been used. These were mounted on a sheet of paper which was subsequently treated in the same way.

21 Frottage

Frottage, a technique developed in the surrealist works of Max Ernst, is the process of obtaining rubbings from surface textures. The rubbings are subsequently cut or torn and used for collage.

There are many interesting surfaces around us, in the home, at school, or in nature. Exciting results can be obtained from heavily grained wood, for example. Heelball, wax crayons, *Conté* and chalk are the most useful for taking rubbings. Cartridge (drawing) paper is generally suitable, but thinner quality paper such as newsprint (kitchen paper) can be used if the texture is shallow or elaborate. The rubbing is made by placing a sheet of paper over the texture and holding it firmly in place whilst the crayon is rubbed systematically across it. The crayon is used on its side and it is usually best to rub it across in one direction and then in the opposite direction, applying pressure gradually. With deep textures care must be taken not to tear the paper. Rubbings can be combined or superimposed.

Figure 77 illustrates the use of shapes cut from various rubbings to form a collage.

Frottage work is often combined with other collage techniques.

22 Collage and graphic techniques

Collage work need not necessarily be regarded as an end in itself. The collage can form the basis for additional graphic work, cut or torn shapes being combined with toned or painted areas. A theme worked in paper can be developed by drawing or painting over it. Paper might be used with a mixture of several other media. Collages can involve almost any material and any technique.

Examples of some of the more obvious uses of combined graphic and collage techniques are shown in the remaining illustrations in this book. In figure 78 acrylic paint has been used, the cut-out shapes being impressed into this and allowed to dry. If applied with a piece of card or palette knife, acrylic colours can also be used to create rich impasto or textured effects. These paints dry very quickly, which is an advantage as far as the completion and storage of work is concerned, but necessitates a quick, definite approach. Water-colour paints are useful for applying thin washes of colour, a technique which can be particularly effective when the colour is allowed to run into the torn edges of parts of the design. Washes can be applied with a piece of sponge or a large soft brush. Areas can be masked out with paper shapes and the collage spray-painted. The reader wishing to

experiment in this way is recommended to seek information from books dealing specifically with such techniques.

In figure 79 the collage has been added to an ink drawing. As always, the correct relationship must be sought between graphic and collage work. In this case the paper has been selected not only with regard to the subject matter printed on it, but also to tone. The shapes have been cut to fit into particular parts of the drawing, and further integration has been achieved by redrawing some lines so as to run across collaged areas. With imagination, the use of combined techniques and mixed media can lead to numerous variations.

In this context mention should also be made of the possibilities of applied paper collage. Posters, for example, might well combine pasted-on cut-outs with lettering. Collage can

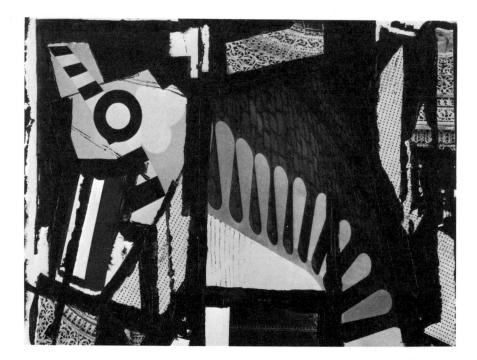

78 Using acrylic paint

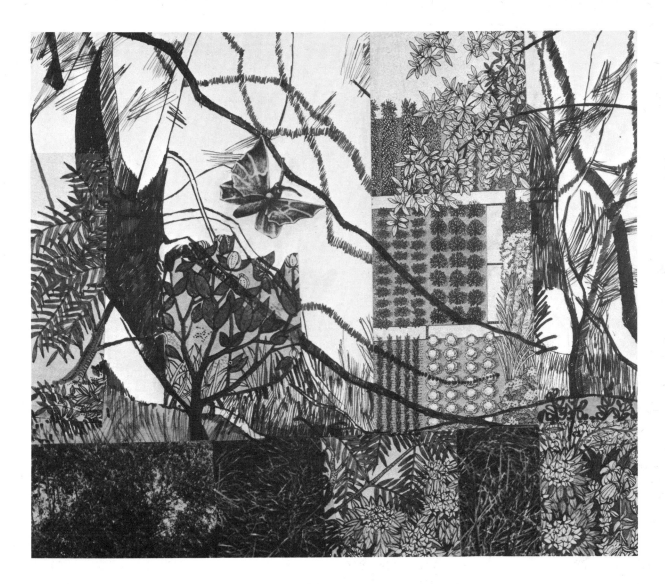

be used in the design of birthday and Christmas cards, a wall
decoration, a collage screen, and so on. Inventive use of the
medium can lead to impressive and interesting results.

79 Combining collage with
drawing

23 Printed surfaces and collage prints

The use of printed papers such as those found in magazines and newspapers has already been mentioned. As well as this, interesting and varied material can be made by employing some of the simpler forms of print making. When the prints are dry they can be cut or torn and used in a variety of collage techniques. Similarly, the print can be used as a support or background on to which other shapes are pasted.

In figure 80 shapes have been cut from various discarded prints to form a collage. The example illustrates the variety of textures and the contrast of tones which can be obtained from the use of such printed surfaces.

The addition of collage and graphic work to basic prints is illustrated in figures 81 and 82. Again, discarded or proof prints could be used for this purpose.

Interesting prints can be obtained from heavily textured and embossed papers, such as crinkled paper, embossed wallpaper, and corrugated paper, though any type of paper could be used. Shapes cut or torn from these types of paper are glued with impact adhesive or other strong glue to a base of thick cardboard or hardboard to form a block. When dry, the block may be inked and a print taken by covering it with a sheet of paper which is then burnished with a spoon, a

80 Using shapes cut from prints

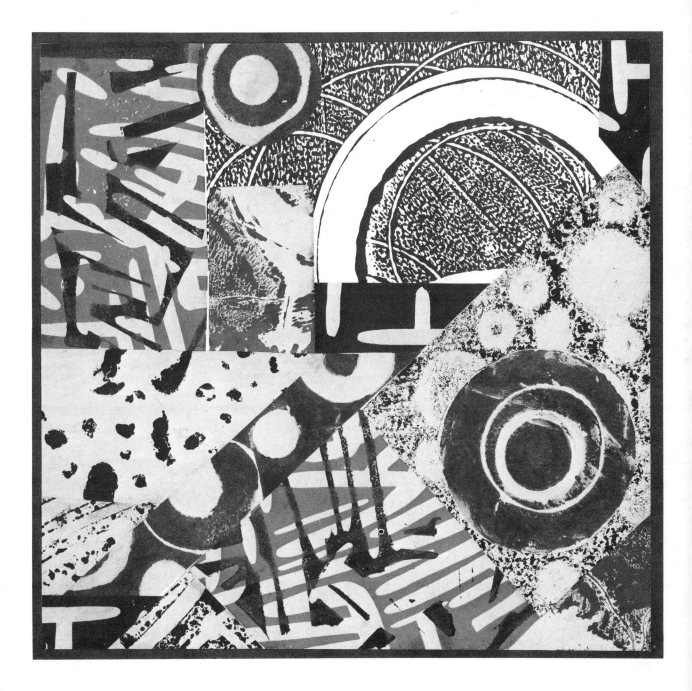

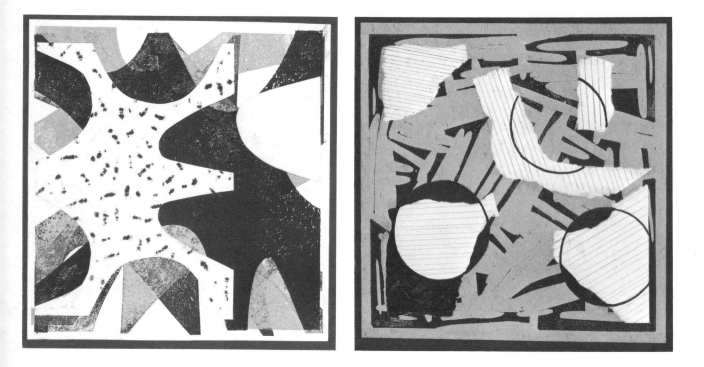

81 Collage combined with printmaking

82 A print with added collage and graphic work

rag, or a roller. Collage prints usually involve the combined use of paper with shapes cut from other materials and 'found' items such as matchsticks and bottle caps.

Print impressions of surface textures are taken in a similar way to rubbings (section 21), except that the paper is rolled with an inked roller instead of being rubbed over with a crayon. Any inked surface which has been scratched into or masked out in some way will produce a print. The reader wishing to experiment with printed surfaces and collage prints is recommended to seek information from books dealing specifically with such techniques as they are too numerous to describe here. The bibliography and back flap of this book list some suitable titles.

Technical notes

The notes below summarize information on aspects of the work. They will serve as a general guide. Variations and additional information on specific techniques have been detailed in appropriate parts of the text.

Tools

Basic equipment includes a good sharp pair of scissors and a paste brush. It is a help to have both a small and a large pair of scissors so that intricate as well as general cuts can be made. A stencil knife or razor-blade, pinking shears, and a rotary punch are other useful cutting tools. Rubber rollers are useful for flattening surfaces and essential for combined collage and print-making work. Palettes, containers (plastic cups or glass jars), a variety of brushes, rags, sponges and a palette knife should be available, and painting, drawing, and printmaking equipment as required.

Papers and supports

The papers and support or base on to which they are glued will depend upon the collage technique being used. Offcuts of all types of art papers should be saved for this work. Tissue and Japanese papers are particularly useful, also gummed paper, old books, news-papers, magazines, wrapping paper, wallpaper, foil papers, etc. 'Found' papers can include tickets, wrappers, cartons, stamps, old photographs and negatives, receipts and scraps of waste paper in general. Most paper collage can be made on a support of thick paper (cartridge or art paper), or card, though firmer, non-warping surfaces such as hardboard, plywood, glass, stretched canvas and Perspex *(Plexiglas)* can also be used. Collages on a paper support which have curled up at the edges can be flattened by placing them under heavy pressure, for example between drawing boards, for a period of 24 hours or so. One must ensure that such collages are reasonably dry so that surplus glue does not stick to the boards.

Paper to be used in collages which are to have additional washes of paint worked over them can be 'stretched' before use. Card can be sized. To 'stretch' the paper it is first soaked in clean water, either by holding it under the tap or by applying water to it with a sponge. Strips of gummed paper are then used along the edges of the paper to stick it to a drawing board or similar surface. When it has dried, the paper may be carefully removed and cut to desired sizes.

Collection and storage

The accumulation and selection of materials becomes a fascinating process in itself. Large collections will benefit from a system of classification and storage. Papers might be stored together because of their colour, shape or texture. One might build up a collection of faces, hands, letters, printed surfaces, wrappings and so on.

Adhesives

Most papers will stick adequately with a liquid glue such as *Gloy*. Acrylic mediums thinned to the correct consistency are useful, as the medium can also be used as a varnish over the finished collage. Work on a heavier support may require an impact adhesive such as *Copydex, Evostick, Bostik* or *Uhu*. Other suitable glues may be found in the list of suppliers.

Pasting

It is often easier to work with glue which has been poured into a shallow container or palette. Shapes must be pasted on a clean surface and the working area organized accordingly. In most instances the pieces should be generously pasted, particular attention being paid to edges and corners. Shapes may be 'pasted-up' on sheets of waste paper (newspapers and magazines), a practice which can avoid mess as the waste paper can be thrown away after use.

Some collage techniques require special methods of pasting and these are mentioned in relevant parts of the text.

Overworking

Paper collages may be overworked by employing various graphic techniques, or by fumage or décollage (sections 17, 20 and 22).

Fixing

The completed collage can be strengthened and protected by a coating of varnish or acrylic medium. These can give a matt or gloss finish to the work, as desired. Paper varnish, *Cryla No. 1 Gloss Medium, Cryla No. 2 Matt Medium, Marvin Medium* and *PVA Medium* are all suitable. Added graphic work, especially that done in pencil, chalk or crayons will require an application of fixative to prevent it smudging and offsetting. Fixative is obtainable in aerosol cans or may be applied from a bottle, using a spray diffuser.

Display

Completed collages which have been fixed or vanished and which are completely dry, can be trimmed, mounted and framed. Mounts are best made from thick card. The collage is attached to the back of the mount with adhesive tape or glue. Mounted work can be framed under glass. Work on stretched canvas, backed hardboard, or similar heavy materials, can be framed or edged with wooden battens.

Suppliers

Great Britain

Paints, crayons, inks, papers and general art materials

Fred Aldous
The Handicrafts Centre
37 Lever Street
Manchester 760 IUX

E. J. Arnold
(School Suppliers)
Butterley Street
Leeds LS10 1AX

Reeves Dryad
Northgates
Leicester LE1 4QR

Educational Supply Association
Pinnacles
Harlow
Essex

Margros Limited
Monument House
Woking
Surrey

Reeves and Sons Limited
Lincoln Road
Enfield
Middlesex

George Rowney and Company Limited
10 Percy Street
London W1

Winsor and Newton Limited
Wealdstone
Harrow
Middlesex

Papers

F G Kettle
127 High Holborn
London WC1
(for coloured tissue papers, etc)

Spicers Limited
19 New Bridge Street
London EC4

Offcuts may be obtainable from local printers

Adhesives

Gloy Schools Service Association
Adhesives Limited
8th Avenue Works
Manor Park
London E12
(for *Gloy multiglue*)

Copydex Limited
1 Torquay Street
Harrow Road
London W2
(for *Copydex*)

Liberta Imex Limited
Liberta House
Scotland Hill
Sandhurst
Camberley
Surrey
(for *Uhu*)

Margros Limited
Monument House
Monument Way West
Woking
Surrey
(for *Marvin Medium*)

These and other glues are available from most
stationers and hardware stores

USA

General art materials

Grumbacher
460 West 34 Street
New York

The Morilla Company Inc
43 21st Street
Lond Island City
New York

and

2866 West 7 Street
Los Angeles
California

New Masters Art Division
California Products Corporation
169 Waverley Street
Cambridge
Massachusetts

Stafford-Reeves Inc
626 Greenwich Street
New York NY 10014

Winsor and Newton Inc
555 Winsor Drive
Secaucus
New Jersey 07094

Mail order service is available from

Arthur Brown Inc
2 West 46 Street
New York NY 10036

A I Friedman
25 West 45 Street
New York NY 10036

Papers

Andrew/Nelson/Whitehead Paper Corporation
7 Laight Street
New York NY 10013
(for Oriental and European papers of all types)

Yasutomo and Company
24 California Street
San Francisco
California 94111
(for Oriental papers)

Chicago Cardboard Company
1240 N Homan Avenue
Chicago 51

Japan Paper Company
100 East 31st Street
New York

Adhesives

Eagle Pencil Company
Danbury
Connecticut
(for *Marvin Medium*)

Other types of adhesives are available at paint,
wallpaper and hardware stores

Further reading

Collage: Personalities, Concepts, Techniques, Harriet Jarvis and Rudi Blesh, Pitman, London and New York

Découpage, Dorothy Harrower, Barrows, New York

Collage and Found Art, Dona Meilach and Elvie Ten Hoor, Van Nostrand Reinhold, New York

The Art of Assemblage, W C Seitz, The Museum of Modern Art, New York

Principles of Collage, Brian French, Mills and Boon, London

The Technique of Collage, Helen Hutton, Batsford, London; Watson-Guptill, New York

Creating in Collage, Natalie D'arbeloff and Jack Yates, Studio Vista, London

Creative Collage, Ivy Haley, Batsford, London; Branford, Massachusetts

Design in Photo Collage, H Stevens, Van Nostrand Reinhold, New York

Creative Photography, Aaron Scharf, Studio Vista, London; Van Nostrand Reinhold, New York

Basic Design, Maurice de Sausmarez, Studio Vista, London

Introducing Fabric Collage, Margaret Connor, Batsford, London; Watson-Guptill, New York

Introducing Seed Collage, Caryl and Gordon Simms, Batsford, London; Watson-Guptill, New York

Dada; Art and Anti-Art, Hans Richter, Thames and Hudson, London; McGraw Hill, New York

A Concise History of Modern Painting, Herbert Read, Thames and Hudson, London; Praeger, New York

Creative Corrugated Paper Craft, Rolf Hartung, Batsford, London; Van Nostrand Reinhold, New York

Pictures with Coloured Paper, Lothar Kampmann, Batsford, London; Van Nostrand Reinhold, New York